island funeral

Photography by
BILL DOYLE

with a text by
Muiris Mac Conghail

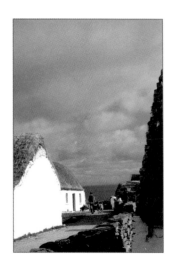

VERITAS

Published 2000 by
Veritas Publications
7/8 Lower Abbey Street
Dublin 1

Copyright © Bill Doyle, 2000
Text © Muiris Mac Conghail, 2000
ISBN 1 85390 527 5

Acknowledgements
A depth of gratitude to the people of Inis Oírr. I wish to thank Maura Hyland,
Toner Quinn, Kathleen Conneely and Monica Conneely, and a special thanks
to Muiris for an outstanding text – Bill Doyle

Veritas Publications wishes to acknowledge the help given by Comhar
Chaomháin Inis Oírr in providing texts of traditional island prayers and the
assistance of An t-Ath. Clement Mac Mánuis CSsR. Many of these prayers
have been published in *Tearmann Caomáin*, eds Ríta Uí Fhlatharta and Bríd
Ní Chonghaile (Údarás na Gaeltachta, 1998). The versions of 'An Phaidir
Gheal' and 'Ag Dul Isteach san Eaglais' are published in *Ár bPaidreacha
Dúchais*, ed. An t-Ath. Diarmuid Ó Laoghaire SJ (Baile Átha Cliath:
Foilseacháin Ábhair Spioradálta, 1990) and are reproduced with kind
permission of the publishers. The poem 'Do Dharrach Ó Direáin' by Máirtín
Ó Direáin is published with kind permission of Niamh Sheridan Ó Direáin.
'Árainn i bhFad i gCéin' by Pádraic Standún was published in *Oidhreacht na
nOileán – Léachtaí Cholm Cille XXII*, eagarthóir An Canónach Pádraig Ó
Fiannachta (Maigh Nuad: An Sagart, 1992). All English versions of prayers,
texts and poems are by Muiris Mac Conghail.

The publishers wish to acknowledge the help and assistance given by Professor
Séamas Ó Catháin, Dr Críostóir Mac Cárthaigh and members of the staff of
the Department of Irish Folklore at University College, Dublin, and for
permission to use an extract from the folktale 'Bainríon Oileáin an Uaignis'
from the Department's manuscript archive, collected by Ciarán Bairéad from
the recital of Joe Mháirtín Ó Flaithearta, and for the account of the storyteller
contained in the collector's diary.

Designed by Bill Bolger
Printed in the Republic of Ireland by Betaprint Ltd, Dublin

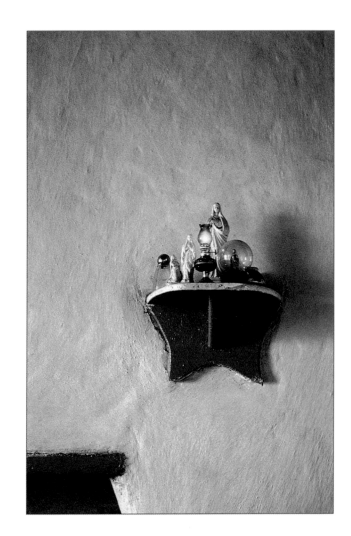

For Tina

AD TE CONFUGIO, sancte Ioseph, Patrone morientium, tibique, in cuius beato transitu vigiles adstiterunt Iesus et Maria, per hoc utrumque carissimum pignus animam huius famuli Joe Mháirtín, in extremo agone laborantem, enixe commendo, ut ab insidiis diaboli et a morte perpetua, te protegente, liberetur . . .

Faoi do thearmann a thagaim, a Iósaif naofa, a phátrún lucht éaga, tusa a raibh Íosa agus Muire ag faire le do thaobh agus tú ag imeacht go naofa ón saol seo, agus trí gheall dóchais na beirte ró-ionúine sin tiomnaím go dúthrachtach duit anam do sheirbhísigh anseo Joe Mháirtín atá ag fáil bháis, ionas go saorfar é faoi choimirce ó mhailís an diabhail agus ó bhás síoraí . . .

Saint Joseph, Patron of the dying, to you do I turn for refuge; at your most happy death Jesus and Mary kept watch. Therefore, by this two-fold pledge of hope I commend most earnestly to you the soul of this servant Joe Mháirtín in his last agony, that under your protection he may be safe from the snares of the devil and from eternal death . . .

Thus it was that the prayer of appeal to Saint Joseph, patron saint of the dying, was made for the safe journey to the resurrection of Joe Mháirtín Ó Flaithearta of Baile an Chaisleáin, Inis Oírr, who died 29 June 1965, then in his eighty-fifth year. 'Gluais, a anam Chríostaí, amach as an saol seo. In ainm Dé . . .' (Go forth Christian soul out of this world. In the name of God . . .).

INIS OÍRR is, as its name in Irish suggests (*oírr<oirthir=east*), the eastern isle of the Aran Islands that lie in Galway Bay as an island triptych and bulwark against the great Atlantic Ocean. Inis Oírr is the smallest of the three-island cluster and is located to the south-east. Approaching it from the sea, the signal tower built in 1805 as part of the defense system against a French invasion stands out against the skyline, and below it Caisleáin Uí Bhriain (O'Brien's Castle) of the O'Brien royal dynasty of Clare and Munster, a fourteenth-century tower house built by Clann Thaidhg, located within an Iron Age stone-walled cashel, Dún Formna (ridge fort). The Dún, one of the seven great stone 'forts' of the Aran Islands, of which Dún Aonghusa is the best known, may have had a rather more religious, ceremonial and community function than a military one. Caisleán Uí Bhriain was ravaged by Cromwellian forces in 1652.

The island community of 274 persons in 96 households is Irish-speaking. When Joe Mháirtín died in 1965 there were 345 persons living on the island. The community is centered around the island's villages: Baile An Chaisleáin, Formna to the south, An Baile Thiar, and above them Baile an Lorgain and Baile an tSéipéil. Like the other two islands of Aran, Inis Oírr is rich in prehistoric, early Christian, and medieval remains. The islanders' memory and traditional place-name lore preserve the names of the saints of the early Christian hermitic community: Caomhán, Éanna, Gobnait, her church, Teampall Ghobnait, also known strikingly and mysteriously as Cill Ghrá an Domhain (the church of the love of the world).

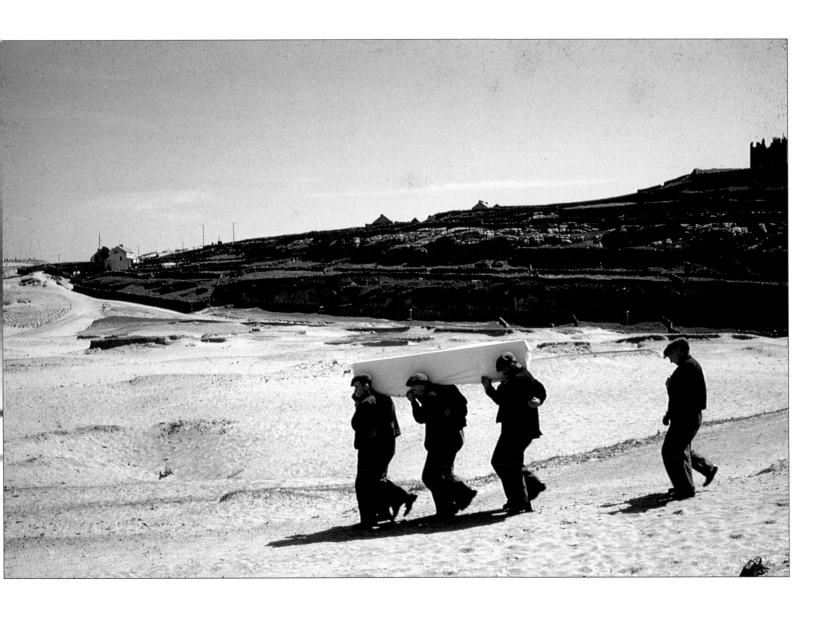

— 3 —

INIS OÍRR now has an airstrip, below what survives in the sand of the medieval church dedicated to Saint Caomhán, and between it and the little bay of Port na Cille. Travelling to Inis Oírr, and, indeed, to the other Aran islands, is now an easy matter: by air from Indreabháin or by rapid ferry from Ros A'Mhíl in Conamara, or by boat from Doolin in County Clare.

Until comparatively recent times, a visit to the Aran Islands was truly a voyage to another time, another world. This is the 'latter end of the world' to which James Joyce brought John Alphonsus Mulrennan in *Portrait of the Artist as a Young Man* (1916), the world that the American film-maker Robert Flaherty fabled on celluloid in *Man of Aran* (1934), and, most enduring of all, the world that was brought to life in John Millington Synge's accounts of the islanders' life in *The Aran Islands* (1907). While Synge's work on the islands, and, indeed, his photographs, were to set the tone for much of the portrayal of the islands, it was Joyce who expressed the unease that the surviving Irish-speaking peoples of the west of Ireland would present to the English-speaking majority in Ireland.

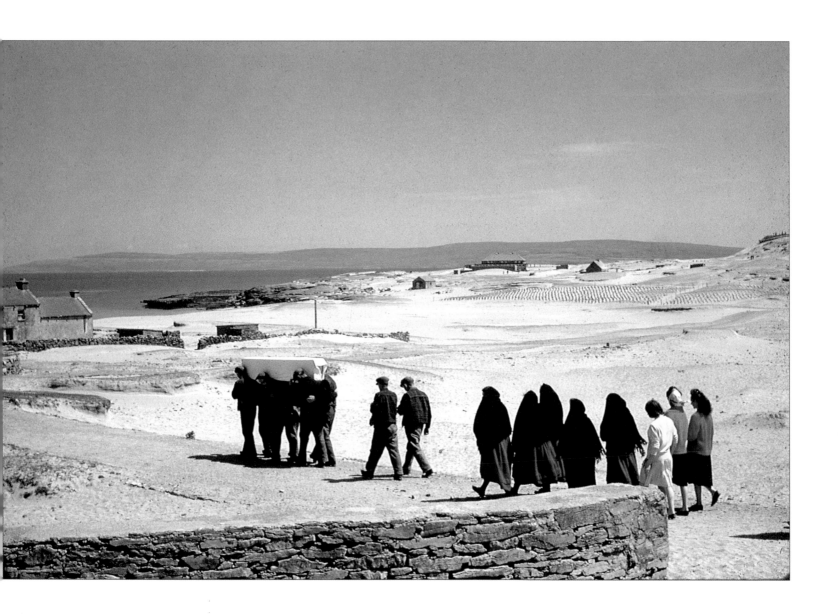

'Another world' was how the painter Seán Keating RHA (1889–1977) described Inis Oírr to Bill Doyle, and Keating's paintings, drawings and sketches, and his filmic record of the island, which he visited for the first time in 1914, show that to astonishing effect. The Aran Islands were the lost world of Gaelic civilisation, almost a submerged culture, which was brought to the surface by Synge in his Aran book, centering, as it did, on the people rather than the eye-catching ruins. Yet the Irish language revival movement could not transfer this world to the center stage in the attempted cultural revolution, and Joyce and Synge both survive in their mastery of the English language and in their contributions to the creation of a new strand of Irish culture in English. Strangely and miraculously, the three islands of Aran survive as Irish-speaking islands in the new and modern Ireland. The island communities were able to sense change and effect their survival from within their own boundaries and resources.

It is over a hundred years since John Millington Synge set foot in Aran, when he left the city of Galway at six o'clock on a May morning in 1898 and arrived at Inis Mór some three hours later. Synge was to spend part of the summers of 1899, 1900, 1901 and 1902 in the islands working on *The Aran Islands* and returning to Paris in the autumn of each year to write. He also took a series of photographs on Inis Meáin and Inis Oírr with his Klito camera, a plate-changing model. All of Synge's surviving photographs are published in *My Wallet of Photographs* (1971).

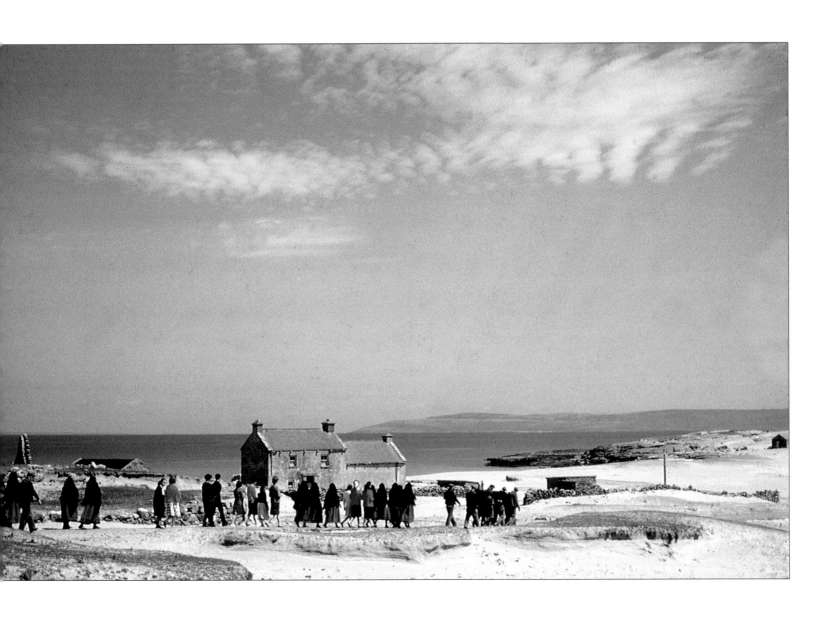

THE YEAR is 1965 and Bill Doyle sailed from Galway on the steamer *Naomh Éanna*. On arrival off Inis Oírr, the vessel was met by a number of the island currachs – the currach is a canvas-covered canoe – and the crews swiftly unloaded both goods and passengers and ferried the lot in and onto the strand and landing place at Inis Oírr.

It was 30 June and the early afternoon sun lit the sand and limestone karst and mixed both with the cerulean colour of sea and sky to a heightened effect. The sand-covered island glowed.

No sooner had Bill Doyle arrived, than he began to photograph the crew of a currach with a Rolleflex and FP4 stock. He heard a churchbell. It was shortly after two o'clock in the afternoon. Then he noticed the black-shawled woman with a red petticoat moving behind a group of men away across the strand and into the dunes. Six islandmen were shouldering a coffin shrouded in white. The sight was both magnificent and terrifying.

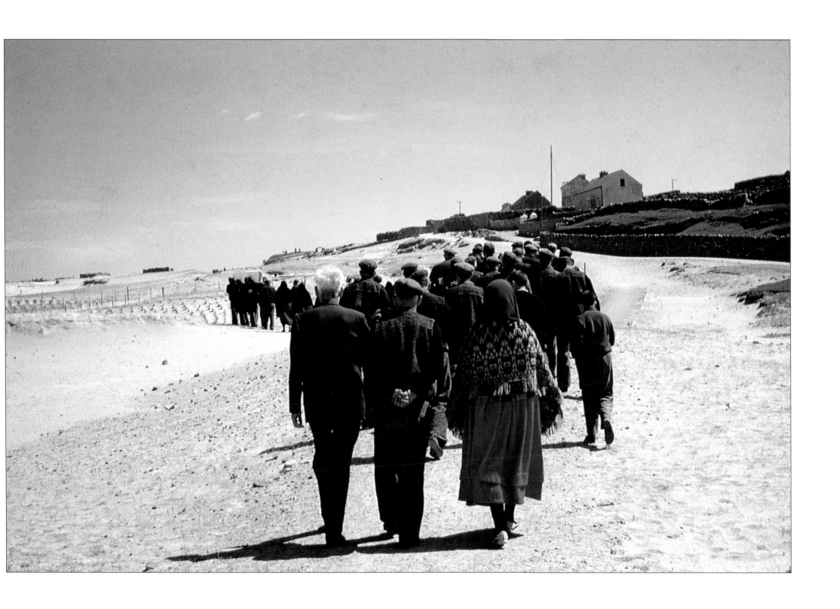

Bill had two cameras, a Leica Mk 2 with an Elmar f2.8 50mm lens, with two rolls of colour Kodachrome 2, and his Rolleflex with a stock of three rolls of black and white SP (125 asa and 25 asa). The stock was the sum of all he could afford on his first visit to Inis Oírr and Aran. The funeral procession was winding its way to the graveyard at Teampall Chaomháin. The woman was one of a dozen, most shawled in black with red petticoats, but some shawled in plaid. John Synge had seen such a procession himself in the islands. The women in his encounter were 'cloaked in red petticoats' and he had seen them from behind also. The red had a strange effect to which, as he observed, 'the white coffin and the unity of colour gave a nearly claustral quietness'. Indeed, at a distance, the shawled women with the red skirts look like a group of robed ecclesiastics, almost cardinal-like against the sky and sand. The light meter was frantic even at 250 @ f11 because of the enormous and glowing quality of reflected light from sky, sea and sand — incandescence. Would or could the celluloid when exposed contain the images?

Téann mo cháirde liom mar a théim
Síos bóithrín na háilleachta
Áit a gcruinníonn ár gcáirde cléibh
Cé'n fáth mar sin go mbeadh faitíos orainn
a dhul i measc ár muintire féin?

My friends go with me to where I go
Down the road of beauty
Where our bosom friends congregate
Why then should we be afraid
to be amongst our own?

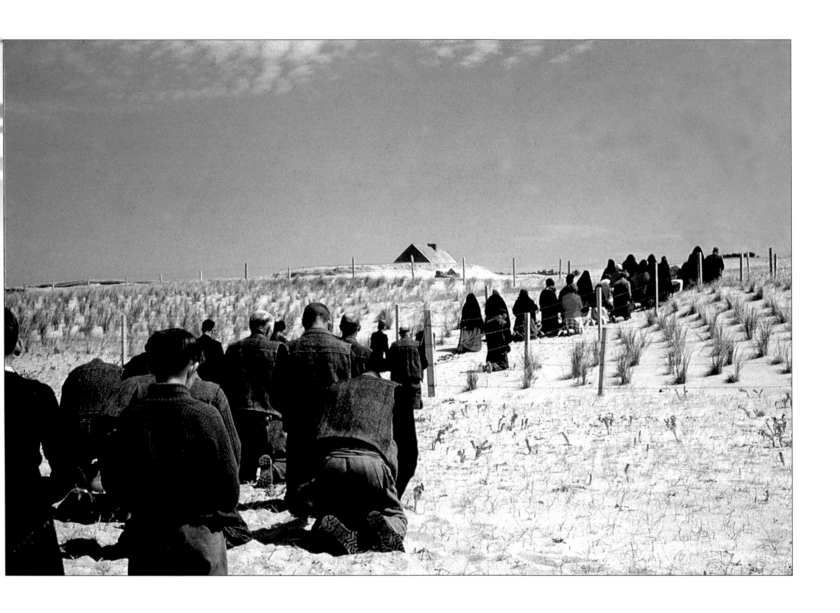

Would Bill have enough stock, and of the right kind, to complete the recording of the images? A stranger in the island, might his actions be intrusive? The camera is positioned behind the mourners and catches them, using the Elmar lens, in dunes and on high, in groups and singularly. Curiously, part of the impact of the pictures is that we rarely see the faces of the mourners: we can conjure up grief. When I saw this sequence of pictures I was taken aback. The power of the images – I could hardly bring myself to look at them. Surely it must be a Greek funeral and certainly that of a hero.

Ná sil deoir ar a leacht	Don't drop a tear on their tomb
Mar d'imir siad a mbeart go fial	For they fought the good fight
Ba neartmhar a mbuille san ár	Their thrust was strong in battle
'S anois ní náir dóibh bheith 'na luí.	And now they are not ashamed to rest.

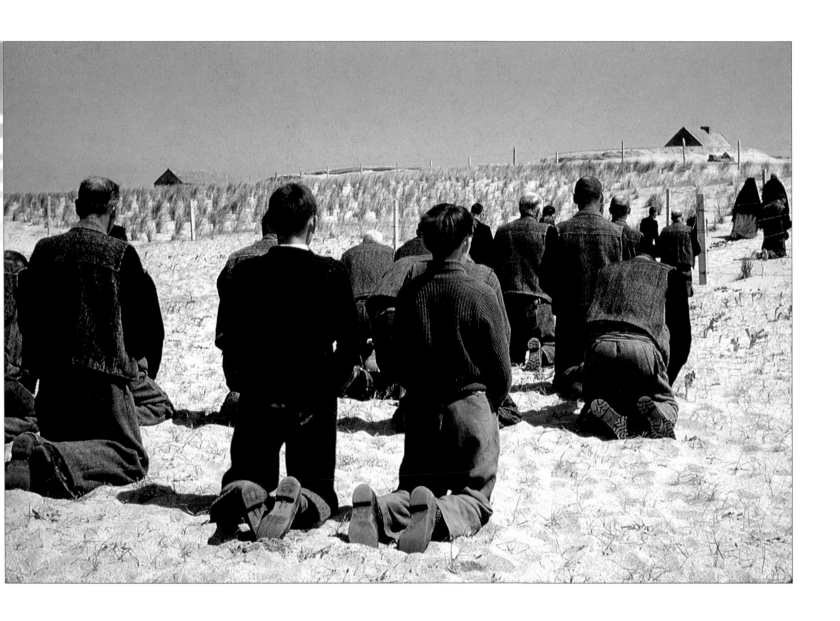

An Phaidir Gheal

Go mbeannaí Dia dhuit, a Phaidir Gheal.
Go mbeannaí Dia is Muire dhuit.
Cár chodail tú aréir?
Faoi chosa Mhic Dé.
Cá gcodlóidh tú anocht?
Faoi chosa na mbocht.
Cá gcodlóidh tú amárach?
Faoi chosa Naomh Pádraig.
Céard é sin romhat amach?
Tá, na haingle.
Céard é sin i do dhiaidh aniar?
Tá, na haspail.
Céard é sin ar do ghualainn dheas?
Tá, trí bhraon d'uisce an Domhnaigh
a chuir Muire liom ag déanamh eolais
ó thigh Phádraig go dtí tigh Pharthais.
Bríd agus a brat, Micheál agus a sciath,
dhá láimh gheala ghléigeala Mhic Dé
Ag cumhdach an tí agus a mbaineann linn
arís go maidin.

The Prayer of Light

God's blessing attend you, Prayer of Light.
God and Mary's blessing to you.
Where did you rest last night?
By the feet of the Son of God.
Where will you rest tonight?
By the feet of the poor.
Where will you rest on the morrow?
By the feet of Saint Patrick.
What is that before you?
Clearly the angels.
What is that behind you?
Clearly the apostles.
What is that on your right shouder?
Clearly three drops of the water of the Lord
With which Mary sprinkled to guide me
From the house of Patrick to the House of Paradise.
Bridget and her cloak, Michael and his shield,
The two bright immaculate hands of the Son of God
Shelter the household and those around us till dawn.

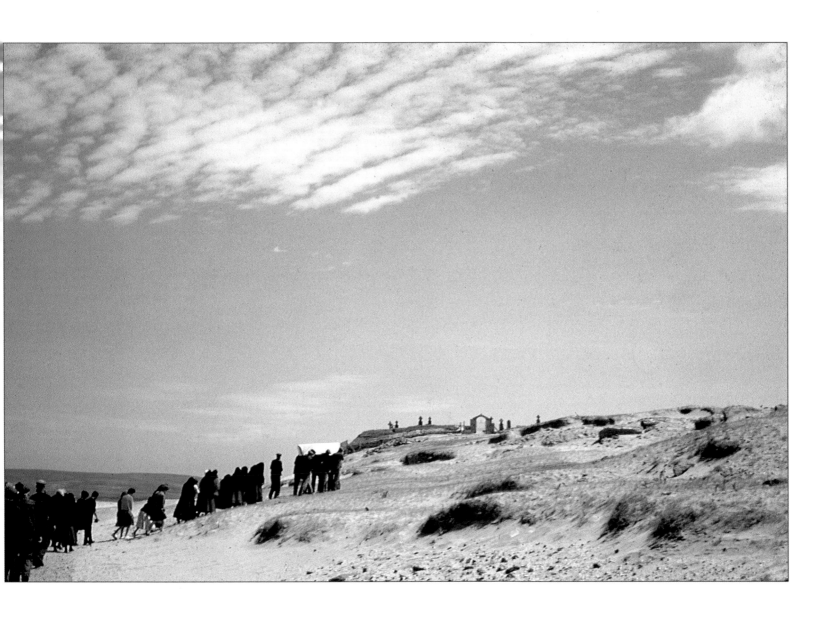

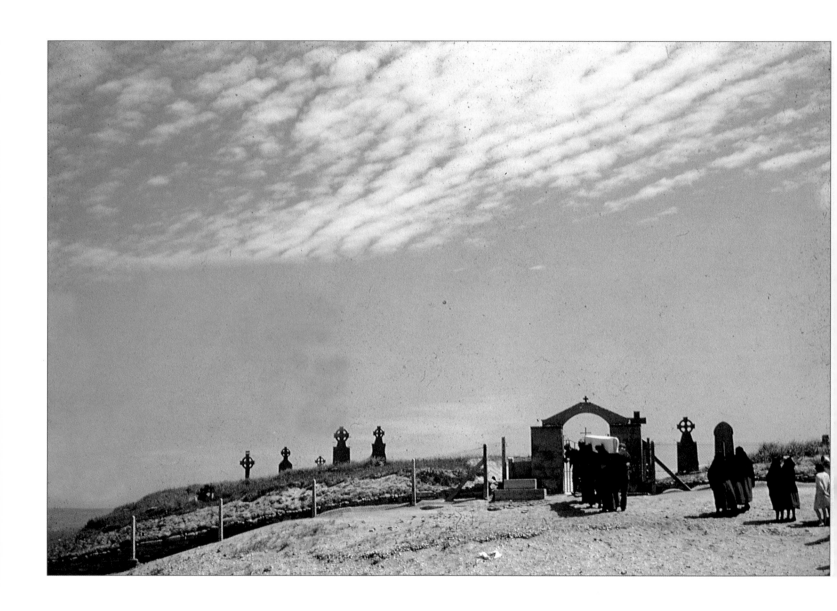

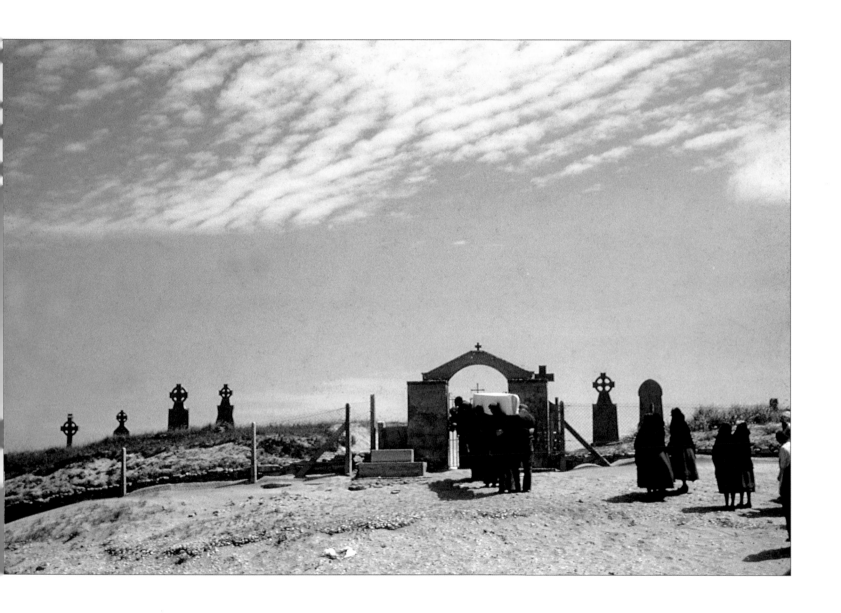

TEAMPALL CHAOMHÁIN, the church of Caomhán, is the scene of the burial and is located to the south-east of An Trá – the landing place on Inis Oírr. Here is the site of a medieval church and to the north-east is the reputed grave of the saint (Leaba Chaomháin) marked by a beautiful cross-inscribed slab. The seventeenth-century Gaelic historian Roderick O'Flaherty (1629–1718) has suggested that Caomhán (beloved person) was a brother of Caoimhín (Kevin, beautifully born one), the abbot of the great monastery of Glendalough in County Wicklow, and that both, perhaps, had been trained by Éanna (Saint Enda) of Inis Mór. The grave of Caomhán had, according to tradition, curative powers, and, indeed, O'Flaherty wrote that the sick and injured were known to 'lye overnight, and recover health of God, for his sake I have seen one grievously tormented by a thorn thrust into his eye, who by lying soe in St Coeman's burying place, had it miraculously taken out, without the least feeling of the patient; the mark whereof, in the corner of his eye, still remains.'

Caomhán is the patron saint of the fishermen of the island, and, when storm and gale beset the island fishing crews, their families and relatives would appeal to the saint to calm the sea, calling 'Cá'il tú a Chaomháin?' (Where are you Caomhán?), taking sand from his grave, and casting it upon the troubled waters to pacify the sea and bring the fishermen safe to shore. The 'pattern' (*patrún*) day of Caomhán is celebrated on 14 June, and, on both it and the vigil, an elaborate ritual of the *turas* (pilgrimage) is celebrated.

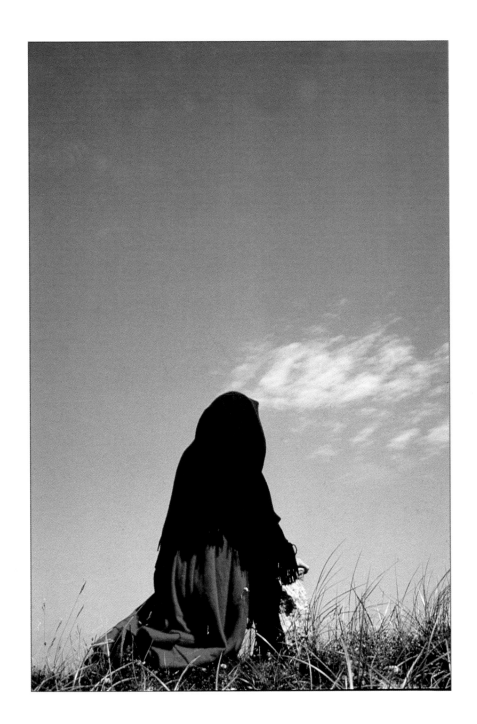

Faoistín Leapan

Luím ar an leaba mar a luífinn san uaigh
Déanaim m'fhaoistín leat a Íosa go crua
Tré ghníomhartha mo cholainne
Tré smaointe mo chroí
Trí amharc mo shúl
Tré labhart mo bhéil
Tré shiúl mo chos
Tré gach rud a dúras agus nach raibh fíor.

Tré gach gealltanas nár chóimhlíonas
Gach a rinneas i gcoinne Do dhlí
nó na thola naofa
Iarraim maithiúnas ar Rí mór na Glóire.

A Confession before Sleep

I lie in my bed as I would in my grave
I confess to you Jesus earnestly
Through the actions of my body
Through the thoughts of my heart
Through the sight of my eyes
Through the words of my mouth
Through the walk of my feet
Through everything I said which was untrue.

Through every promise I made that was not fulfilled
Through everything I did against Your commandments
or your sacred wish
I beg forgiveness from the great King of Glory.

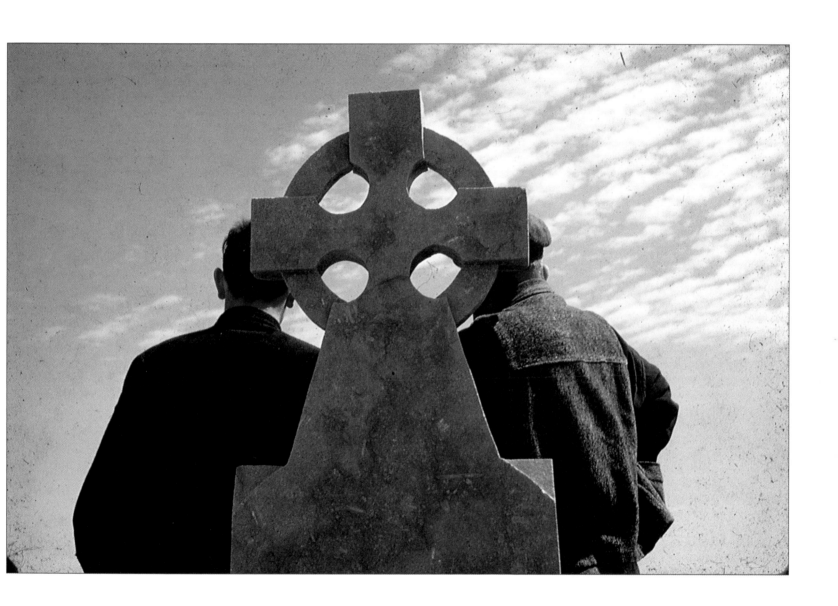

The procession to Teampall Chaomháin is rooted in time, and the ritual in need. The Bill Doyle sequence follows the way of the cortège down across the machair below the village, as the six islanders shoulder the white, shrouded coffin, almost borne as in posture of dance, with the post-noon sun casting feet-shadows forward.

Ag Dul Thar Reilig	Passing a Graveyard
Beannaím daoibh a fhíréana Chríost	I salute you the faithful of Christ
Atá anseo a' fanacht le haiséirí glórmhar	Who rest here awaiting the glorious resurrection
An Té a d'fhulaing páis ar bhur son	May He who suffered the passion on your behalf
Go dtuga sé suaimhneas síorraí daoibh.	Grant you eternal rest.

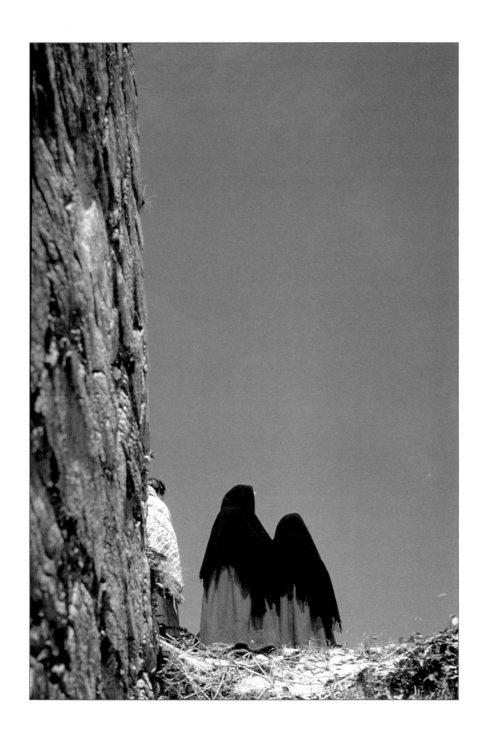

The island men are dressed in homespuns, with a blue or greyish back to their waistcoats and a brownish tweed to the front. *Ceann easna* was the grey homespun at the back – *ceann easna sa chúl agus glas caorach sa tosach.* The tweed cap replaced the *caipín bobailín* – the knitted headgear of Synge's time. Some of the men wear a sleeveless jacket of the same homespun material over which the waistcoat is worn, while others wear a tweed jacket without lapels. Around their waists a *crios* – a fine threaded interwoven band – and their shoes are made of cowhide – *brógaí úrleathair.*

The women wear black, paisley or plaid shawls covering their heads and bodices, and the remarkable red petticoats.

The funereal group went as it came and vanished into the island.

De profundis clamo ad te, Domine Domine, audi vocem meam.

Out of the depths I cry to Thee, O Lord; Lord, hear my voice.

Screadaim as na duibheagáin ort, a Thiarna; a Thiarna, éist le mo ghlór.

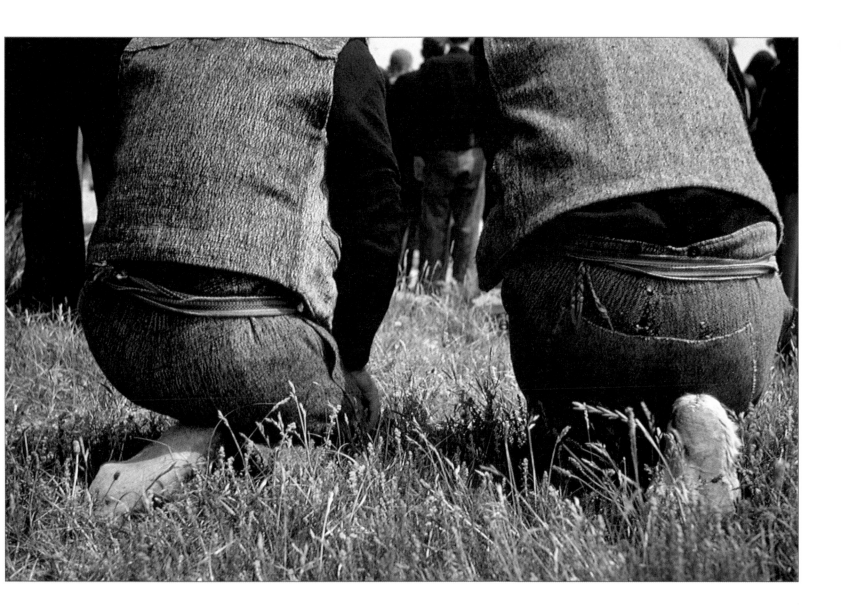

Ag Dul Isteach san Eaglais

Beannaím duit, a theampaill Dé
agus go mbeannaí tú féin dom,
mar shúil agus go mbeidh an dá aspal déag
ag guí orm féin inniu.
Íslím ar mo ghlúin dheas don Ardrí
agus ar mo ghlúin chlí don Spiorad Naomh,
mar shúil go dtógfainn
a mbeidh romham
agus i mo dhéidh
ó leac na bpian.

Entering a Church

I bless you, temple of God
and may you also bless me,
in the hope that the twelve apostles
are prayerful of me today.
I supplicate myself on my right knee to the High King
and on my left knee to the Holy Spirit,
in the hope that I may secure
those before me
and those after me
from the pit of pain.

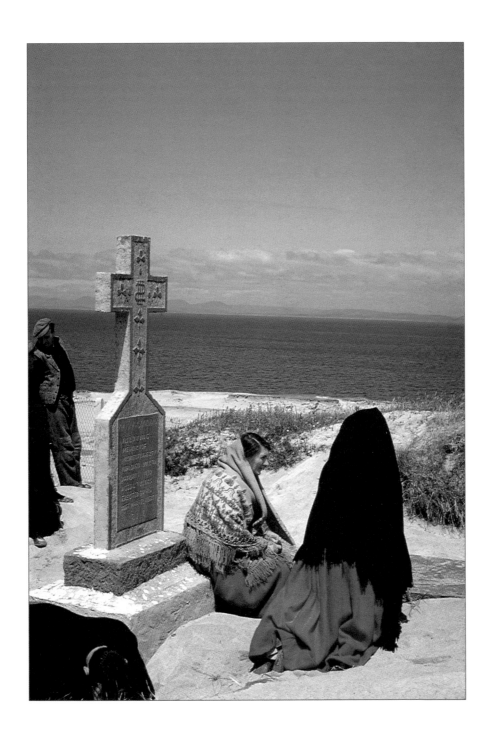

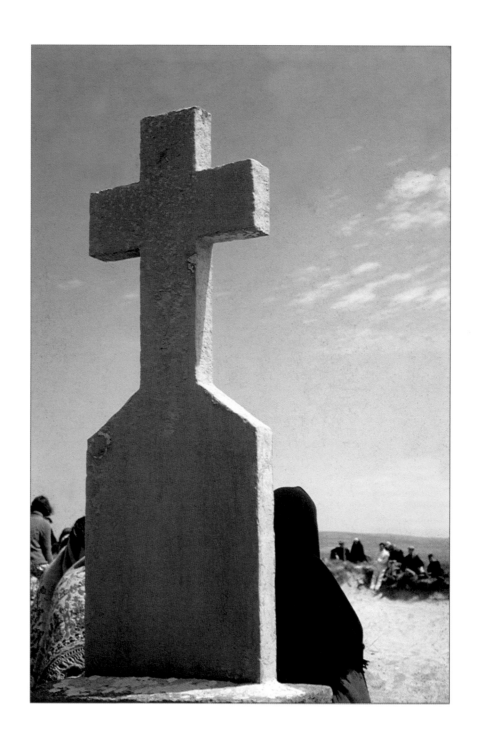

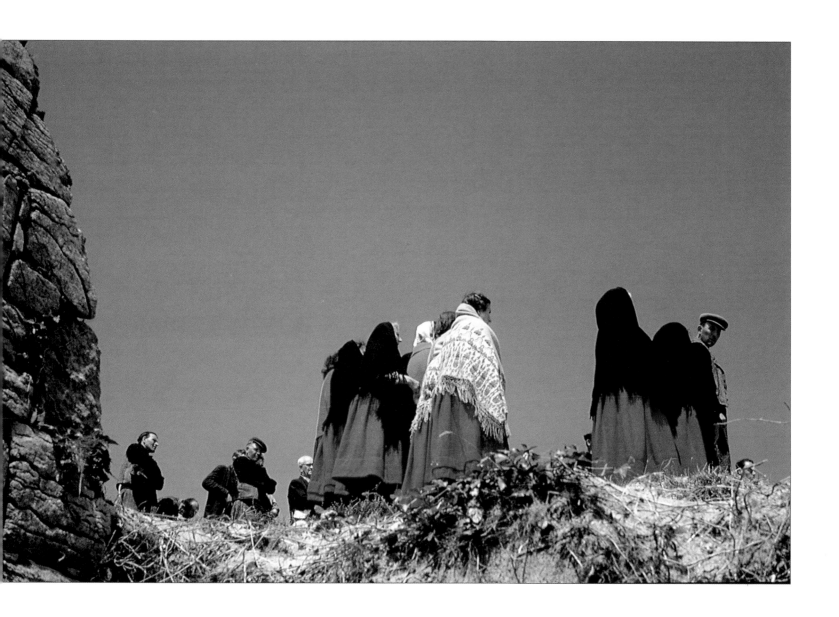

JOE MHÁIRTÍN Ó FLAITHEARTA lived all his life in Baile an Chaisleáin at Ceathrú an Chaisláin, Inis Oírr. As its name suggests, Baile an Chaisleáin (Castletown) rests below the castle of the O'Briens – Caisleán Uí Bhriain. The village overlooks An Trá – the strand, the landing place and beaching point for the currachs.

Joe Mháirtín Ó Flaithearta, son of Máirtín, son of Brian *(a'tsagairt)*, was four score and five years and married twice. His first wife was Maigí (Pheaitsín Chóilí) Chonghaile who died in childbirth. Joe Mháirtín married again and his second wife Bríd (Bidí) was the sister of Pádraig Ó Gríofa, the basket maker *(fear na gciseóg)* of Baile an Chaisleáin. There were no children of the second marriage. He died on the Feast of Saint Peter and Paul, Lá Fhéil Pheadair is Póil, 29 June 1965, one of the important days in the Aran Islands and the day on which the great regatta is held at Cill Rónáin on the great island, Inis Mór. In fact, many of the younger people of the island were at Cill Rónáin on that day for the regatta.

Joe Mháirtín was an important man in the cultural life of Inis Oírr and a strand in the slender fabric of Irish cultural life. *An scéalaí,* he was one of the surviving traditional storytellers and fortunately some of his repertoire was collected by Ciarán Bairéad in the late 1950s. The material is preserved in that great archive of the Department of Irish Folklore at University College, Dublin. Seamas Ó Duilearga, who held the Chair of Folklore at UCD and was the founding father of the folklore archive, truly laid out the collection's aim by drawing on the words of Jesus

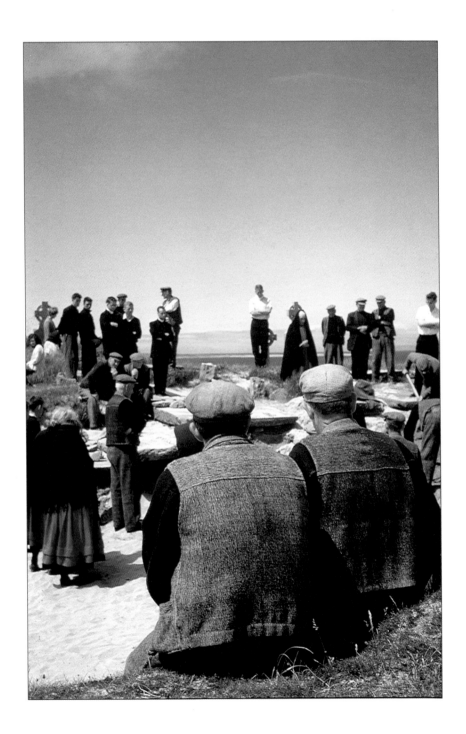

from his sermon on the mount; as John recounts after the miracle of the loaves and fishes, Our Lord told the apostles to collect the fragments lest they perish – *colligate quae superaverunt fragmenta ne pereant* (Jn 6:12).

Ciarán Bairéad (1905–1976), son of Stiofán Bairéad (1867–1921), one of the first members of the Gaelic League and its treasurer for many years, was a full-time collector for the Folklore Commission and the Department of Irish Folklore at University College, Dublin (1951–1975). Bairéad worked throughout the counties of the west of Ireland including Clare and Limerick. His work of 25,000 pages of manuscript in his clear and distinctive hand is preserved in the archives of the Folklore Department at UCD. Ciarán visited Joe Mháirtín at his home in Baile an Chaisleáin on a number of occasions to record stories on ediphone (an early form of the dictaphone that used wax cylinders). The material so collected would be later transcribed verbatim by Ciarán Bairéad and lodged, catalogued and bound into volumes at the UCD Folklore Department's archive. Both Bill Doyle's photographic sequence and Ciarán Bairéad's transcriptions sustain the memory of this island lamentation.

The very first volume of the Ciarán Bairéad transcriptions that I opened (Ms. 1544) contained a pasted-down summary entry thus:

<div align="center">

Joe Ó Flaithearta (Joe Mháirtín)

Baile an Chaisleáin. Inis Oírr.

4.6.'57. Aois 77.

</div>

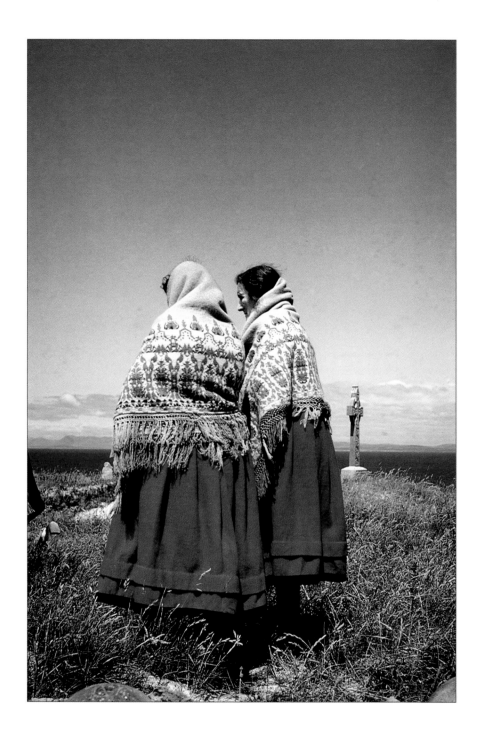

And so, at the age of seventy-seven, on 4 June 1957, Joe Mháirtín recited and Ciarán Bairéad recorded a story entitled *Bainríon Oileáin an Uaignis*, which when transcribed was contained in twenty-five pages of handwritten text.

Ciarán Bairéad gives a short account of that storytelling episode and describes how, when coming ashore at Inis Oírr, he twisted his leg while jumping from the currach, suffered immense pain, and was unable to walk for a time without the aid of a stick. After tea in his lodgings, Ciarán decided to call on Joe Mháirtín that evening and the ediphone recording apparatus was carried by Michael Antoine Mac Dómhnaill, the son of his host. They were accompanied by Iníon Uí Chearbhaill, the school mistress. 'D'inis Joe dhá scéal dúinn agus bhí an-sásamh againn ar an oíche . . .' (Joe recited two stories and we had a very good night . . .). Leo Corduff of the Folklore Commission was also present at the session.

The title of the first of the two stories collected, *Bainríon Oileáin an Uaignis* (The Queen of the Isle of Loneliness), had some kind of emotional impact on me in the context of Bill Doyle's funeral sequence. How apt and appropriate, I thought, in our search for the storyteller.

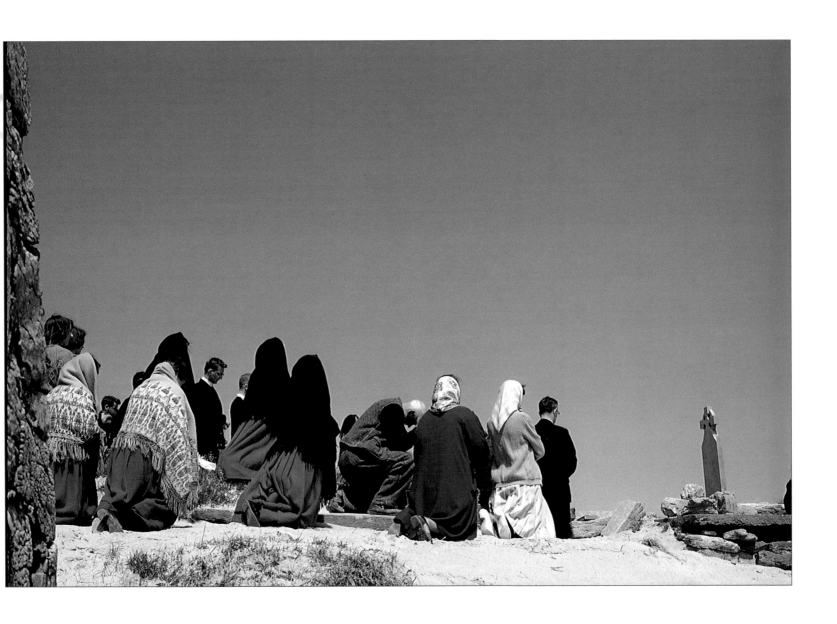

Bainríon Oileáin an Uaignis

Chua sé a' siúlbhlóid, a'spaisteoireacht leis, agus nuair a chua', nuair a tháinic a' deireannas, dhein sé ar a'teach, agus by dad, nuair a dhein sé ar a'teach, bhíodar a c'cinnt's a cuir síós ar a 'saoghal ar an aimsir, nó go ra'sé i n-am codlata.

'Ó', adeir sé, 'bhfuil aon duine a'teacht anseo', adeir sé, 'ach thusa'gus mise? Nach ndeanfa' aon leaba 'mháin muid', adubhairt sé.

'By dad', adubhairt sí, 'creidim go ndeanfa', adubhairt sí.

Chuadar a chodladh. D'fhan mar sin go dtí ar maidin na mháireach, buaileann sí biorán suain ann, agus shín sé siar mín marbh.

D'fhan mar sin. Bhí'n an aimsir ag imeacht, agus nuair a bhí'n an aimsir ag imeacht – go ceann trí rátha.

'Ó', adeir sí – tharraing sí an biorán suain as – 'eirigh 'nois', adubhairt sí, agus baist do mhac – 'baist', adubhairt sí, 'do mhac.'

'Á, a thighearna', adeir sé, 'Má tá mise anseo', adubhairt sé, 'an áit a bhfuil mac óg a'd-sa go mo bhárr', adeir sé, 'níl teach ná árus, soitheach ná duine ná . . .'

'Á', adeir sí, 'ná bíodh aon imridhe ort g'aon sórt ceo beo', adubhairt sí. 'Chuir mise beatha seacht mbliana síos in do shoitheach, agus tá do chuid fir', adubhairt sí, 'chomh maith leis an lá d'fhága tú iad.'

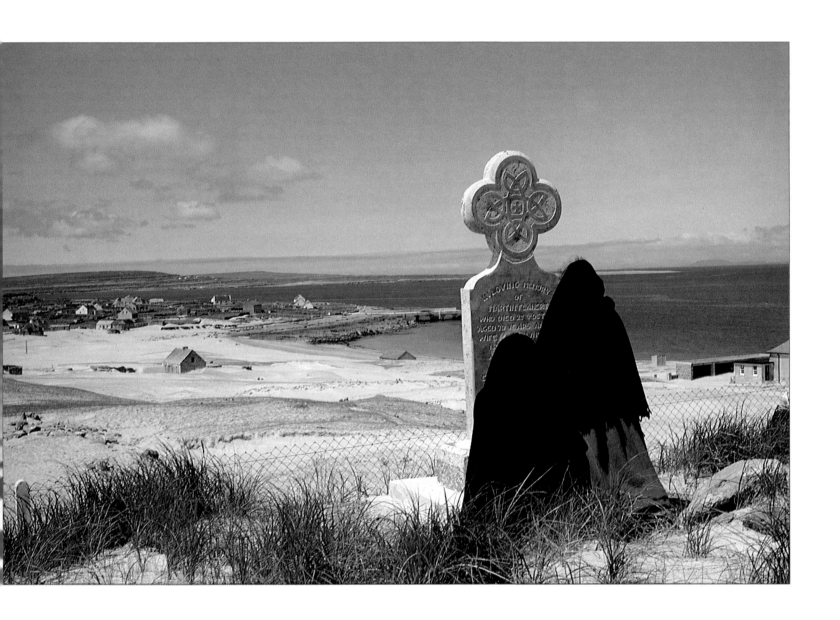

The Queen of the Isle of Loneliness

On a visit to a certain island, the warrior and his men discovered that there was but one inhabitant who lived in the island castle – a beautiful princess. After supper the warrior went walking around the island, returning to the castle at nightfall whereupon the princess and the warrior spoke of this and that until it was time to go to bed.

'O', said he, 'Is there anybody else coming here but you and I', said he. 'Would not one bed do us both', said he.

'By dad', she said, 'I believe it would', she said.

They went to bed. Things rested so until the morrow, she injects him with a sleeping pin and he stretched out almost as if dead.

Things rested so. Time was passing and so it passed for up to three quarters.

'O', said she – she pulled the sleeping pin out – 'get up now', she said, 'and baptize your son.'

'O Lord', said he, 'I am here', said he, 'where you have had a young son by me. There is neither house or dwelling, vessel or person . . .'

'Ah', said she, 'don't be worried', said she. 'I put seven years down into your vessel, and your men', said she, 'are as fit as the day you left them.'

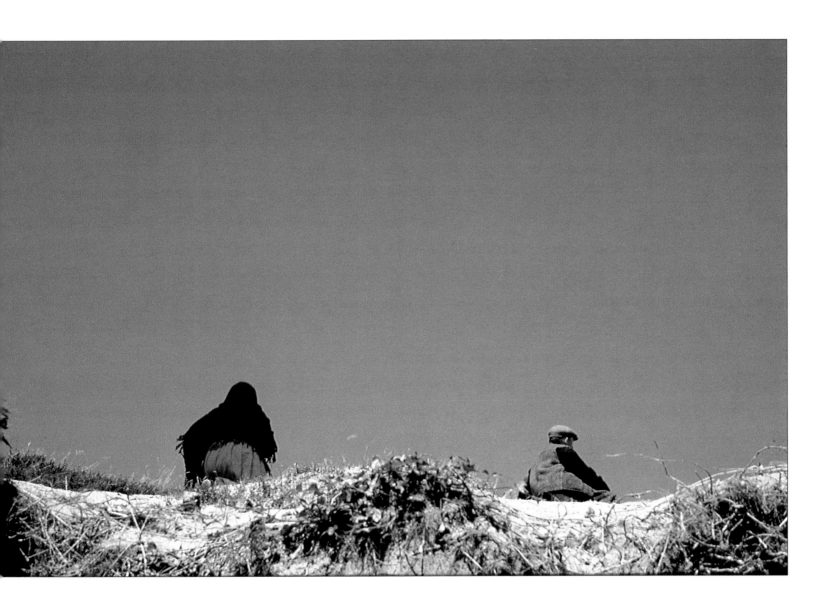

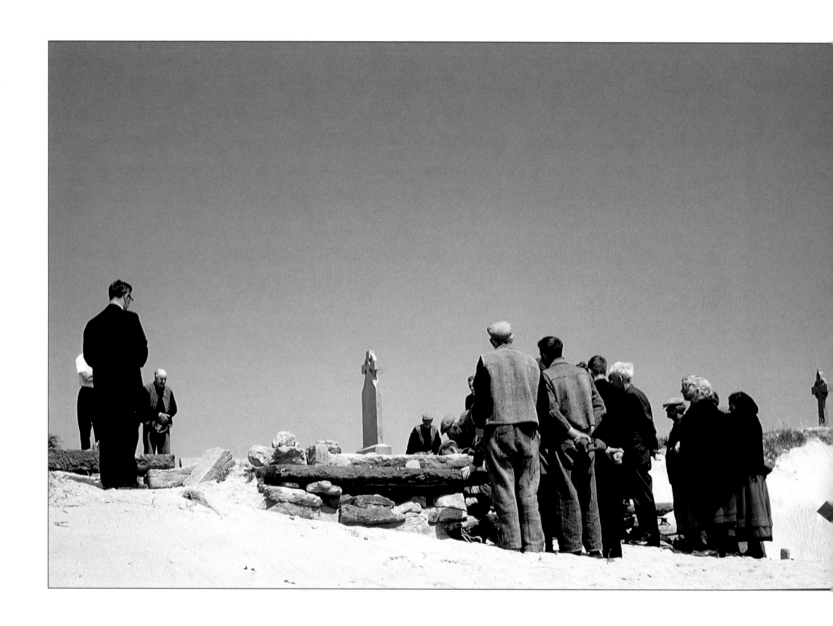

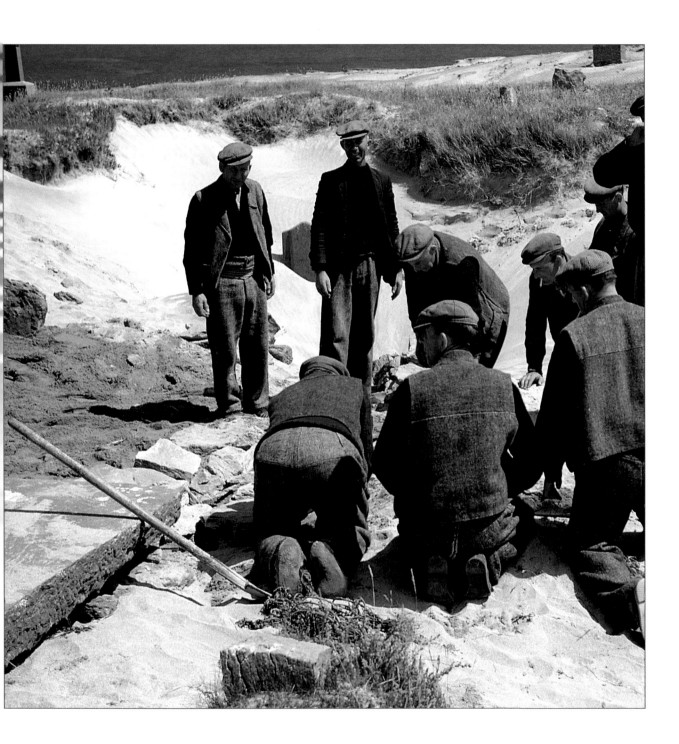

JOE MHÁIRTÍN's death at eighty-five years would, of course, have been a cause of sorrow for the community at Baile an Chaisleáin, and for the island community as a whole. But it would also have marked the passing of one of the old order, the *fear seanchais* – the keeper of the tradition, the traditional lorist, the teller of stories – *an scéalaí*. The loss of Joe Mháirtín would have been a community loss, another strand gone in the woven fabric of its culture. People from the island would have understood, more than many might imagine, the tragedy involved in such a death. For the world in which the Aran people live is a world of continuity: everything in its place and an explanation for everything based on a strong inheritance of racial memory, fuelled and sustained both by a deep faith and the echo and touchstone of tellers of tales and the singers of song. Without church, state or status for their language, these people inherited and transmitted much of the texts of their faith orally from generation to generation – *ó ghlúin go glúin, ó bhéal go béal*. Their 'pomp and circumstance' is illustrated in the liturgy of their funeral for Joe Mháirtín.

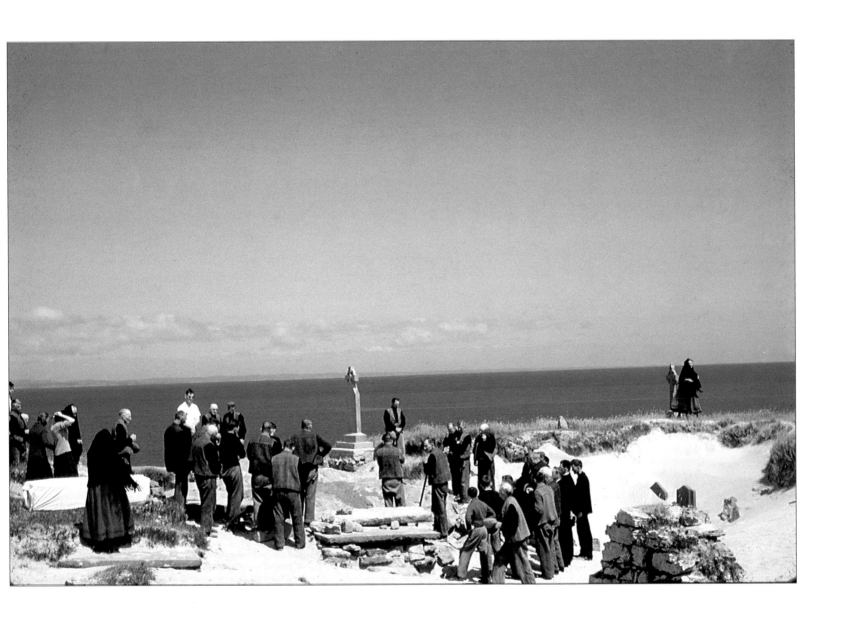

I suppose some at the funeral on that day would have recalled and remembered the stories of the storyteller and smiled at the recollection. Others, in thinking of eternity, might have asked, as the Aran poet Máirtín Ó Direáin asked of the storyteller Darach Ó Direáin of Eoghannacht:

Do Dharach Ó Direáin

Cé'n scéal, a Dharaigh ón tír úd thall?
Ar casadh Seáinín ort ná Séamus fós?
A bhfuil Mac Rí Éireann féin san áit?
A bhfuil Fionn Mac Cumhaill ná Conán ann?
A raibh an Chailleach Bhéara romhat sa ród?
Scaoil chugainn do scéal, a Dharaigh chóir!

To Dharach Ó Direáin

What's the news from the land beyond?
Did you encounter Seáinín yet or Séamus?
Is the King of Ireland himself there?
Is Fionn Mac Cumhaill or Conán present?
Was the Old Woman of Beare on the road
 before you?
Unravel your story, noble Darach!

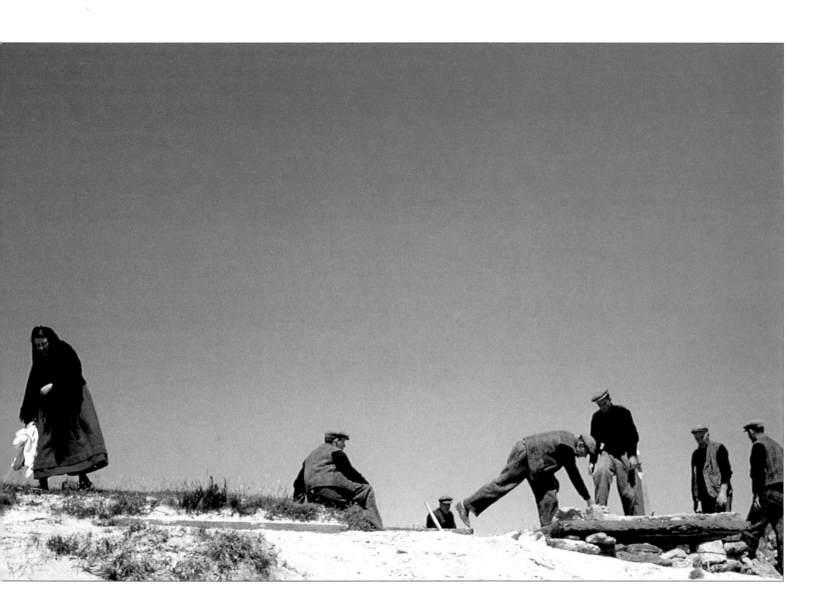

IN THE GAELTACHT areas, but particularly in the island communities, there is a sense of spirituality in the lives of the people who live there. There is an inheritance of prayer from the rich Gaelic tradition of considerable antiquity, and that inheritance is part of the great oral culture informed by medieval tradition and reformed and invigorated when the Gaelic-speaking communities literally went underground and away from the eye of history.

The surviving memories of the lives of the saints of Inis Oírr, the presiding remains of the monastic settlements, associated sites, and, indeed, of Dún Formna itself, all bring together a confluence of imagery, which, when taken with the very nature of a fishing community itself, drawing its harvest perilously from the sea and in the face of storm and drowning, brings a dignity of ritual and prayer to the islanders' lives.

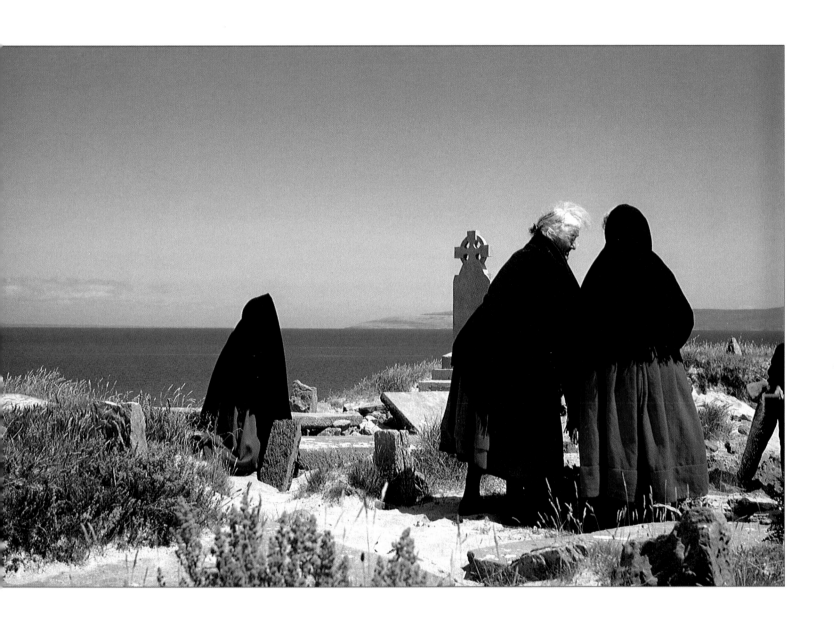

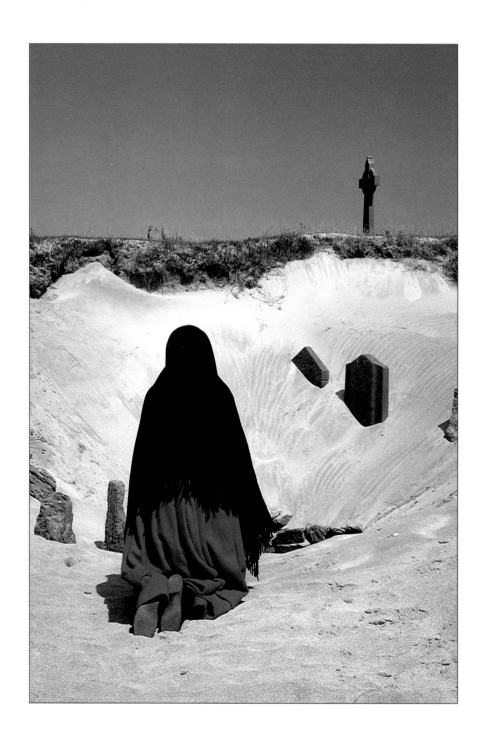

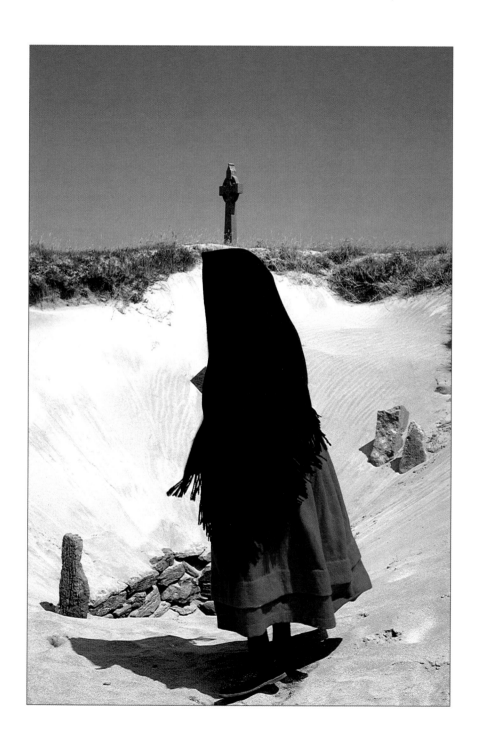

The priest writer Pádraig Standún (*Súil le Breith, Cion Mná,* etc.) who served as curate on Inis Oírr (1971–73), and in the curacy of Inis Oírr and Inis Meáin together (1973–1975), gave a lecture in his old college of Maynooth some years ago on the island experience and on its spirituality:

'Tá spioradáltacht sna daoine a thabharfá faoi deara ina bhfreastal ar Aifrinn, ar phaidrín, agus go háirithe ar ócáidí urnaithe sna reilgeacha, go speisialta i mí na marbh, mí na Samhna. Is beag áit eile a d'fheicfeá fir óga i mbun turais na gcros sa gCarghas nó an cúigiú cuid den phobal ag gnáth-Aifreann na maidne ar laetheanta seachas Dé Domhnaigh. Cúis amháin atá leis seo, déarfainn nó go maireann pobail na n-oileán an-ghar don nádúir, don fharraige, do bhaol a mbáite, do chontúirt na n-eitleán, don dainséar a bhaineann leis an iascaireacht, do ghálaí, stoirmeacha, agus farraigí móra an gheimhridh, a chaitheann duine a fheiceáil len iad a chreidiúint. . . .

Tá spioradáltacht le brath is le mothú sna clocha féin, go hairid seanmhainistir ar nós Teampall Chaomhán in Inis Oírr, Teampall Cheannanach in Inis Meáin, ag tobar Éinne, Atharla Chinndeirge, Teampall Ghobnait agus na toibreacha agus teampaill uile inar tugadh onóir do Dhia leis na mílte bliain . . .'.

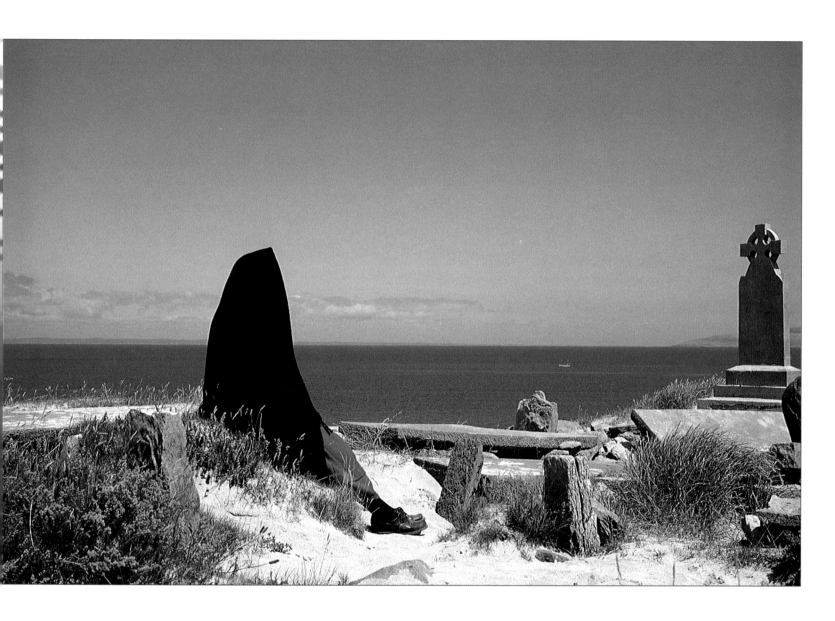

'There is a spirituality in the people that one notices in their attendance at mass, at rosary, and particularly at occasions of prayer in the graveyards, especially during the month of the dead, November. There are few other places in which one would see young men doing the Stations of the Cross during Lent or, indeed, a fifth of the mass-going community at morning mass on days other than Sundays. One reason for this, I would venture, is that the people of the islands live in proximity to the elements, to the sea, to the danger of their being drowned, to the perils of airplanes, to the dangers involved in fishing, to gales, storms and to the high seas of winter that one would have to see to believe. . . .

That spirituality is to be felt and sensed in the very stones, particularly in the old monasteries like Teampall Chaomháin on Inis Oírr, Teampall Cheannanach on Inis Meáin, the well of Éanna, Atharla Chinndeirge, the church of Gobnait, and the wells and churches in which glory was made to God for many years . . .'.

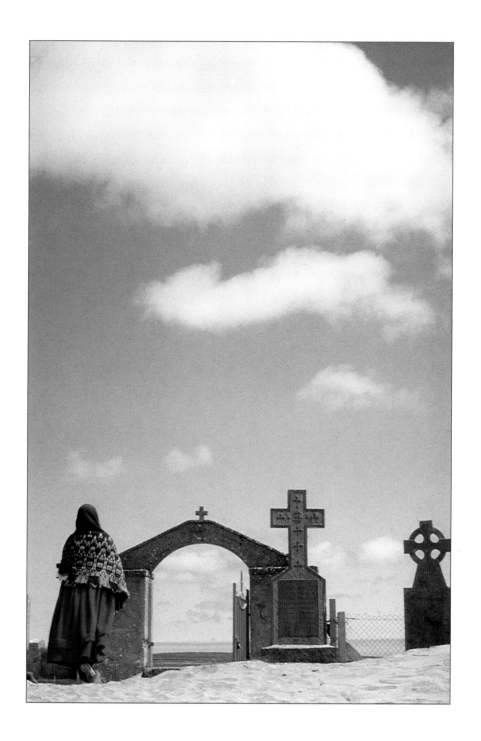

Now this is the observation of a priest who has seen the ways of the world and, indeed, written of them in his novels both in Irish and English. He is also aware, as he has written, that the islands are not those of saints: 'Nílim ag rá gur oileáin na naomh atá in oileáin Árainn . . .'. Standún is the last curate on Inis Oírr to have to minister to the people of Inis Meáin also, and to regularly cross the treacherous Sunda Salach (the 'foul sound') between the two islands in a currach crewed by Inis Oírr men whose turn – 'turn' a't-sagairt – it was to carry the priest to the other island. On such a voyage, in high and dangerous seas, in which only the skills of the boatmen brought him ashore, Pádraig Standún writes: 'Ar lá mar sin a chuirfeá curach i gcosúlacht le bróg Chríost ag siúl ar an bhfarraige . . .' (On such a day you imagine the currach as the shoe of Christ walking the sea . . .). Such was the impact of the islands on the language of the writer.

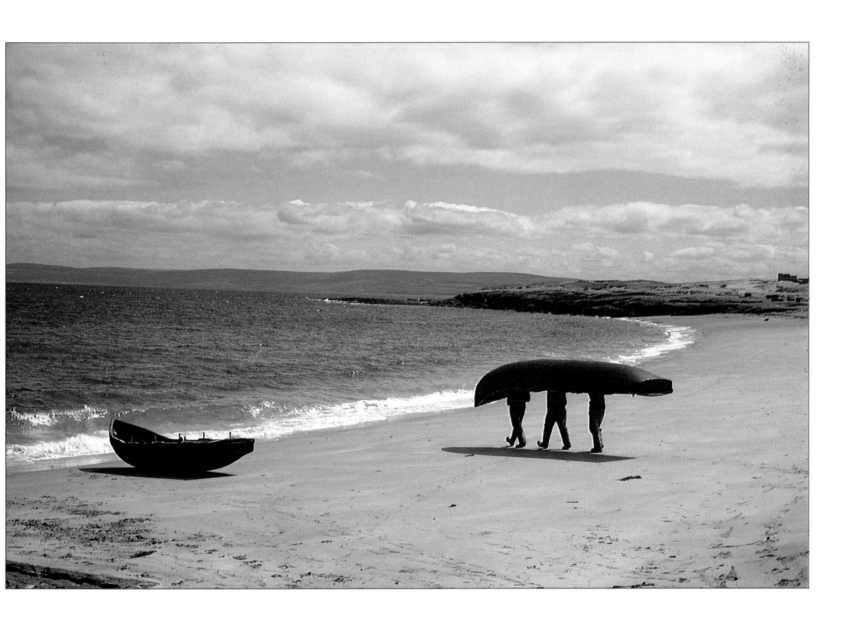

AT THE END of the day, there is one aspect of the lives of the people of Inis Oírr that must be noted – their livelihood was from the sea around them and the lives of the men were spent working the currach, which was not only a means of transport, but the very instrument of their existence. The fishing of *ronnachaí* (mackerel) and the fishing of *bréim* (bream) were the essential ingredients of their trawl. There were seventeen *bréim* beds around the island from Dún an Fhiaidh to Ceann na bhFaochannaí. The most important bed was that known as Poll na gCailleach at the back of the island. Named because the *cailleach* (anchor) was often lost there. The *cailleach* was a large stone with a rope tied around it that was thrown down into the sea to keep the currach steady while fishing for *bréim*. Another important series of beds lay between Inis Oírr and the Clare coast; known as *An Chreig*, it was about two miles in length and marked with buoys.

There was a time on Inis Oírr when upwards of fifty crews fished from it, and certainly the head of every household on the island was a fisherman. So the images of the funeral sequence that Bill Doyle captured on film were that of the funeral of Joe Mháirtín Ó Flaithearta, storyteller to an island fishing community, and, in the long nights of the winter months when the island was storm-bound, the storyteller would narrate the songs and stories of the heroic past so that the community could renew itself for the spring tide.

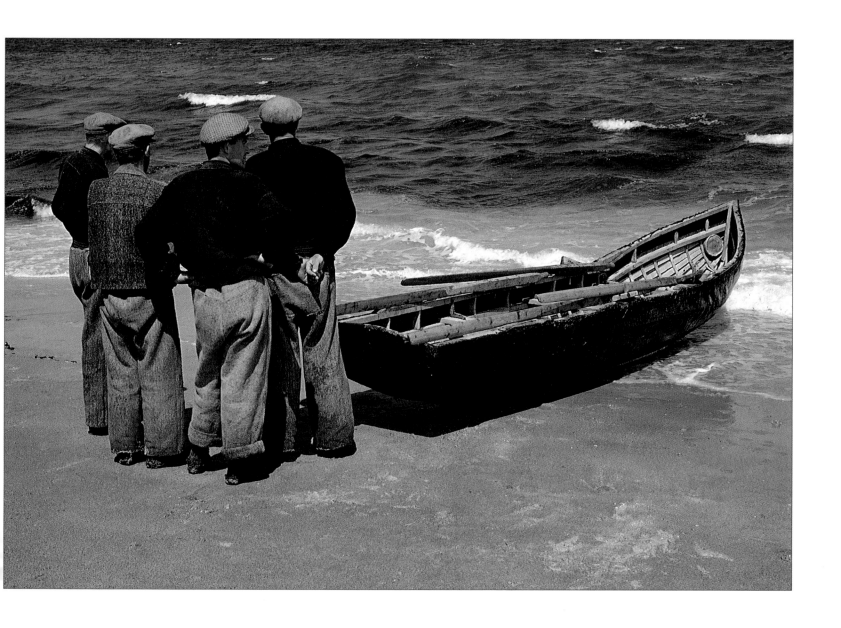

Ag Críost an mhuir,

Ag Críost an t-iasc,

I líontaibh Dé go gcastar sinn.

Be the sea with Christ,

Be the fish with Christ,

Let us be caught in the nets of Christ.

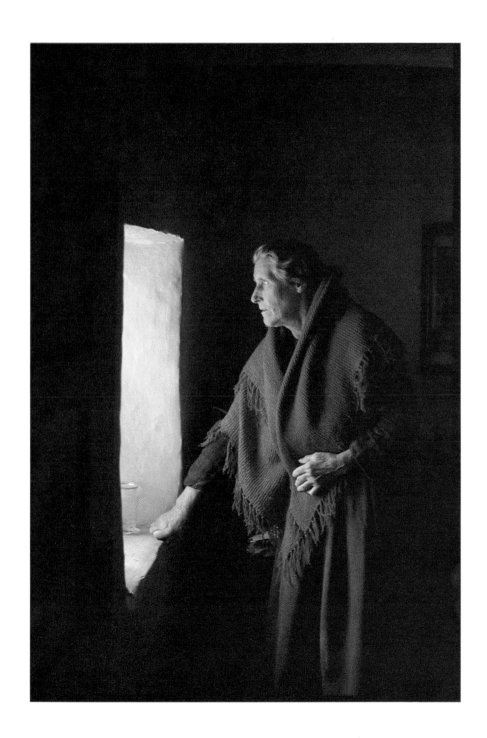